# A Collection of Thoughts

*A selection of poetry.*

# By: Donald Arnold

## INDEX

*Adventure*..................................................Page 3

*An Actor's Lament*.......................................Page 4

*Act II*..........................................................Page 5

*Act III*........................................................Page 7

*Intermission*................................................Page 9

*The Mighty Rail*..........................................Page 10

*An Old Soul*................................................Page 12

*Ghosts*........................................................Page 14

*Someday Soon*............................................Page 16

*Legacy*.......................................................Page 17

*The Bandit Rides Again*...............................Page 18

*Comments from the Author*..........................Page 20

*A Sneak Peek at My Next Work*....................Page 23

### *DISCLAIMER*

*This is a work of fiction. Names, characters, businesses, places, events and incidents are either the products of the author's imagination or used in a fictitious manner. Any resemblance to actual persons, living or dead, or actual events is purely coincidental.*

## *Adventure*

No matter who you are,

Or where you go,

There is one thing

We all must know.

Adventure is far more

Than just a word,

And to think otherwise

Is rather absurd.

Now make no mistake,

By dime, nickel, or quarter.

Despite trials and fights,

Adventure makes the journey seem shorter.

### *An Actor's Lament*

The stage to me is another home.

Other actors a family to me.

A great feeling it is

Brining a story to the scene.

The apron like a peak upon which pioneers stand,

The background a dancing spectacle of lights,

I feel the performance in my heart,

As we prepare for opening night.

In years past some have left us,

Graduated to the next level of the skill.

Who will carry on their memory?

We will.

Now comes the final show of our high school years.

We hold our heads high, feeling brave and bold.

May the show always go on;

May the hot lights never grow cold.

<u>*An Actor's Lament: Act II*</u>

The hot lights,

They welcome me still,

Though tribulations

Struggle with my will.

Trials in life

Try the determined heart.

Always chasing dreams,

Always playing the part.

Few move on

Through the trials of pain,

Just as they would

In a great and driving rain.

Fame is a dream.

Let us make it real.

Achieve always your goals,

However unsure you feel.

Just remember

Through the ages of tales and lore,

A man wears many masks,

But an actor wears many more.

## *An Actor's Lament: Act III*

My love for the stage

Grows ever stronger still.

Though trends come and go,

As they always will.

The lights will now come up again

On the empty stage.

They always have and always will,

Through each and every age.

The stage is like a book,

Its story to be told.

Whether classical, vintage, or modern,

The lights still do not grow cold.

Some call it sentiment,

Some others call it love.

Each and every true actor

Knows this passion I speak of.

And so again this lament,

It comes to an end.

Until the next act,

Break a leg, my friend.

### *An Actor's Lament: Intermission*

The lights are up.

The stage is clear.

It is again

That time of year.

The props are gone.

The bows are took.

The lines are said.

The hands are shook.

Someday soon,

We shall return.

Again to act,

Again to learn.

So take these words,

And heed them too.

When Act I is rough,

Look to Act II.

## *The Mighty Rail*

The hammer hits the spike,

The sound rings through the air.

Won't somebody say

What they're building there?

It runs on the ground,

Through the middle of the town,

One day it will be a mighty fine tale.

The mighty rail.

The sun is hot.

The day is long.

They'll be done,

Before too long.

The mighty rail is rolling

Through these United States.

The might rail is rolling

Carrying that hot load of freight.

Now times have changed,

The rail's still there,

But it itself has changed.

Now that trains are run from computer range.

But somewhere in the desert,

Where the old rail lies,

The coal driven engine,

Rides beneath the sky.

A ghost in our time,

It travels the rail still.

In story and in rhyme,

And many hope it always will.

### *An Old Soul*

Andy Griffith in Mayberry;

Elvis's swingin' tunes;

Johnny Carson on the TV;

Seven castaways marooned.

These are the things that I love.

Oh what a tale of woe!

Things are changing way too fast,

For the dear old soul.

The Possum and White Lightnin',

Folsom Prison Blues,

Best that I can say is:

Who's Gonna Fill Their Shoes?

Some things it does love,

About this time.

Though it always will miss,

The Main in Black who Walked the Line.

These are the things that I love.

Oh what a tale of woe!

Things are changing way too fast,

For the dear old soul.

## *Ghosts*

Since of May of '34,

A legend has been told,

Of two wandering spirits,

On a stretch of Louisiana road.

He is a tall, young man,

Who carries a full loaded gun.

She is a slender, young woman,

Only in it for love and fun.

He was a shooter,

With a keen and careful eye,

But couldn't get to his pistol,

Under the morning sky.

She was the poet,

Writing tales of love and hate,

But innocent or not,

She met a terrible fate.

Their names you ask?

The two spirits walking side by side?

Those two star crossed lovers,

Are none other than Bonnie and Clyde.

## *Someday Soon*

Someday soon, I'll be a star.

Someday I'll prove you wrong.

Someday soon, I'll go far.

Someday I'll sing my song.

Broadway's lights, they wait for me,

To come and take my place.

Broadway's lights, wait day by day,

To light my shining face.

Someday soon, I'll hit the screen.

Someday you'll know my name.

Someday soon, I'll reach my dream.

Someday I'll gain my fame.

## *Legacy*

Legacy.

It was respected by Hamilton.

It was left by Lincoln.

Legacy.

The pioneers brought it across the plains.

The workers hammered it into the railroad.

Legacy.

It was in the car with Bonnie and Clyde.

It was in every speakeasy.

Legacy.

The voice of Elvis sang it.

The dreams of King were filled with it.

Legacy.

It was on the space shuttle.

It turned the century.

Legacy.

These days it remains.

These days we are the ones leaving our

Legacy.

### *The Bandit Rides Again*

He's dusting off the old Trans Am.

He's got the hat on tight.

Look out Sheriff Justice,

Because the Bandit rides tonight.

He's woke up the Snowman,

And now old Fred, he bays.

Frog's in the passenger seat,

Like the good old days.

Now Justice knows he's back,

And he's started up the car.

He's off to chase the Bandit,

Through the sun and stars.

From Malibu to Brooklyn,

The Bandit ducks and runs.

For both Bandit and Justice,

This game is pretty fun.

Now the sun's setting in Houston.

The Bandit doesn't even slow.

The chase goes on and on,

As the tale does go.

## *Comments from the Author*

*Adventure-* This piece was actually inspired by its own last stanza. One day, we had a substitute teacher in my choir class and I wrote that last stanza on the board. From that, *Adventure* was written.

*An Actor's Lament-* This piece was not inspired by its last stanza, but its last line. Talking to a fellow actor, an alumni of my school, I said, "May the hot lights never grow cold," speaking of the legacy of the graduated class. He remarked that I should really write that down. *An Actor's Lament* came shortly after.

*Act II-* The sequel to *An Actor's Lament* shares something with its predecessor. It was also came from its own ending. During a time in my life where I was rather depressed, I wrote, "A man wears many masks, but an actor wears many more." It means that at some point in their life, everybody wears a mask to hide their true feelings, but an actor, someone who plays parts for a living, wears many more.

*Act III-* The third piece of my *Actor's Lament* saga, *Act III* was written as I prepared to take the stage again. I wrote it as a universal message. Every actor who enjoys what they do knows the feeling I was describing. Joy. Excitement. Belonging.

*Intermission-* As one could easily guess, the fourth installment in my *Actor's Lament* saga was written at the

end of the school year, as I saw sets stricken and said goodbye to the stage for a short time, at least until theatre camp.

*The Mighty Rail-* This piece came from nostalgia of the American Railroad, which I find hard to avoid since I take American History classes.

*An Old Soul-* I have been a fan of classic television, movies, and music for years. Johnny Cash, Hank Williams, *Gilligan's Island*, *The Addams Family*, and more held a special place in my heart. Don't get me wrong. Like the piece says, I don't despise my own time, but I am, as many people have said, an old soul.

*Ghosts-* Yet another nostalgia piece, I have a fascination with Bonnie and Clyde. I've visited the memorial and the museum in Gibsland, Louisiana. This piece is a tribute to the couple.

*Someday Soon-* This piece was written as a word to all those who discourage performers. Never be discouraged, my fellow artists. You can do it.

*Legacy-* When I listened to Lin-Manuel Miranda's Broadway smash hit *Hamilton* for the first time I heard the founding father mention the word legacy, so I began thinking, and from my thoughts, came this poem.

*The Bandit Rides Again-* This piece was inspired by Burt Reynolds, Jerry Reed, Sally Field, and Jackie Gleason's *Smokey and the Bandit* trilogy. I loved the films and wrote this tribute to them.

## *A Sneak Peek at My Next Work*

I am currently writing a book called, *The Light of Thardorin: The Forgotten Realm*, and I have decided to share the current draft of the prologue with you. Enjoy!

## Prologue

The year was 1820. Five years after the war of 1812 ended, the United States was still being explored. The soon-to-be disputed land that would be called Texas harbored a place that not even the natives were aware of, a city called Freymoor, which was hidden by magic. Freymoor was home to Humans, Elves, and Dwarves. Very few other species lived there. The King was named Toroq Ra'kal, an Elf from the land once called Taure Eska, or "Forest Home," in the Elven tongue.

The city was never discovered. The Battle of The Alamo, The Civil War, World War I, World War II, and so on passed. The magic never failed. However, during what was called The War of the Necromancer, a thief took one of the books of history, written in Freymoor's common language, not known to those outside the magic wall known as The Barrier. Scouts, disguised often as birds, searched the world for the book, with no luck. The humans had the book. Despite consideration, Toroq could not risk exposing his land to the outside world to retrieve it.

■■■■■■■■■■■■■■■■■■■■■■■■■■■■■■■■■■■■■■■■■■■■■■■

The curator of the New York Museum of Natural History had rarely been surprised by an artifact. However, a new acquisition, a book printed in what looked like combined

Middle English and Latin, was an exception. No translator was able to read the book and the only information the curator received was that it had been in the family of one of his friends for generations.

An advertisement was produced on television, radio, and even printed in the major newspapers. People came from as far as England to try to translate the mysterious book. No one could. No one, that was, until the day Thomas Young came to the museum.

www.ingramcontent.com/pod-product-compliance
Lightning Source LLC
Chambersburg PA
CBHW070309190526
45169CB00004B/1558